containing
illustrations, recipes,
formulas & other activities
to entertain & entice creativity
for the prevention of ennui &
general malaise among
the youth of today &
their progenitors

THE
STEAMPUNK
COLORING &
ACTIVITY
BOOK

created by
Phoebe Longhi

❧ ❧

manic d press
san francisco

ISBN 978-1-933149-63-9

Recipes herein reprinted from *Lee's Priceless Recipes: 3000 Secrets for the Home, Farm, Laboratory, Workshop and Every Department of Human Endeavor*, compiled by Dr. N.T. Oliver (Laird & Lee, 1895)

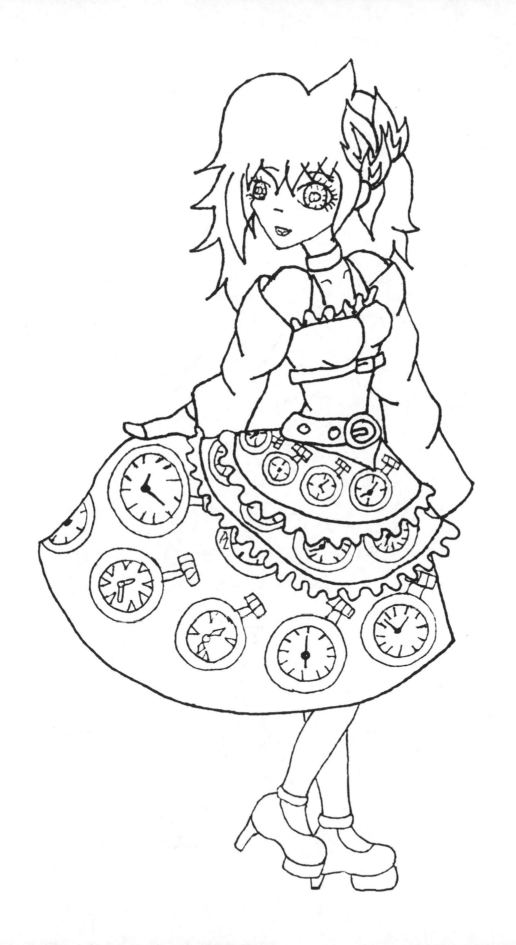

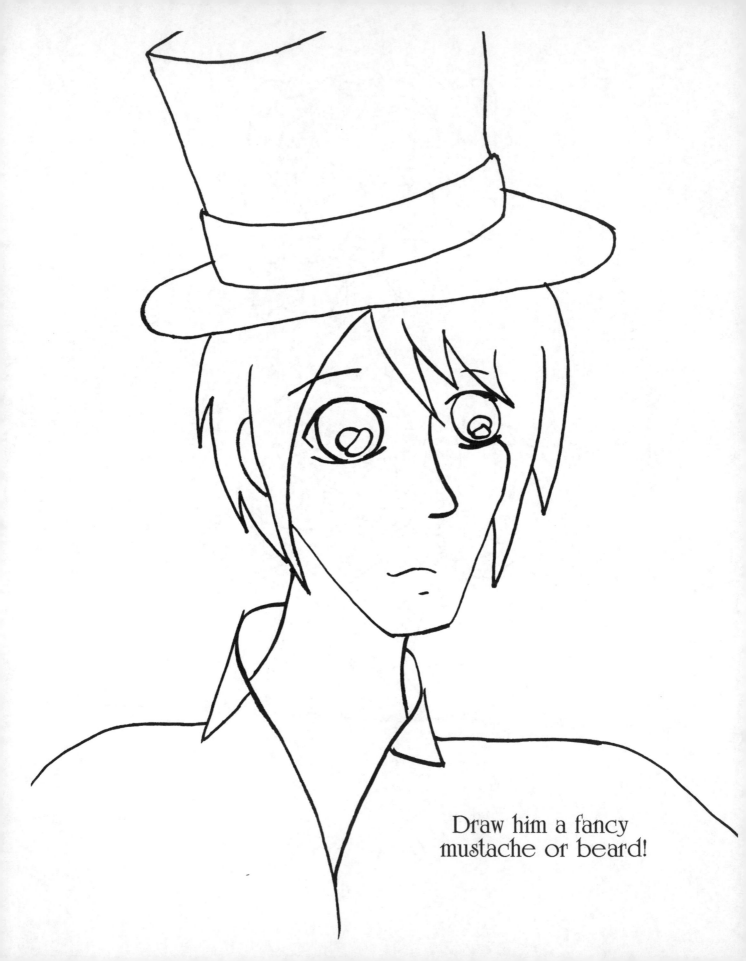

Draw him a fancy
mustache or beard!

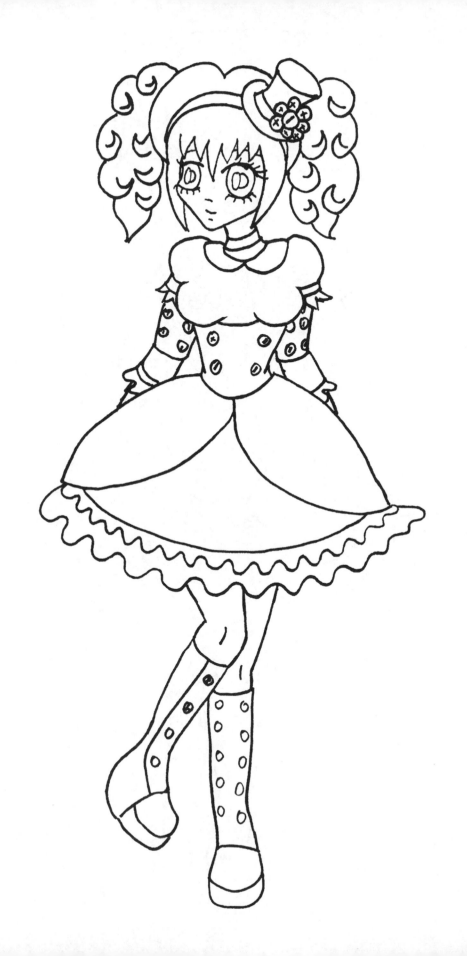

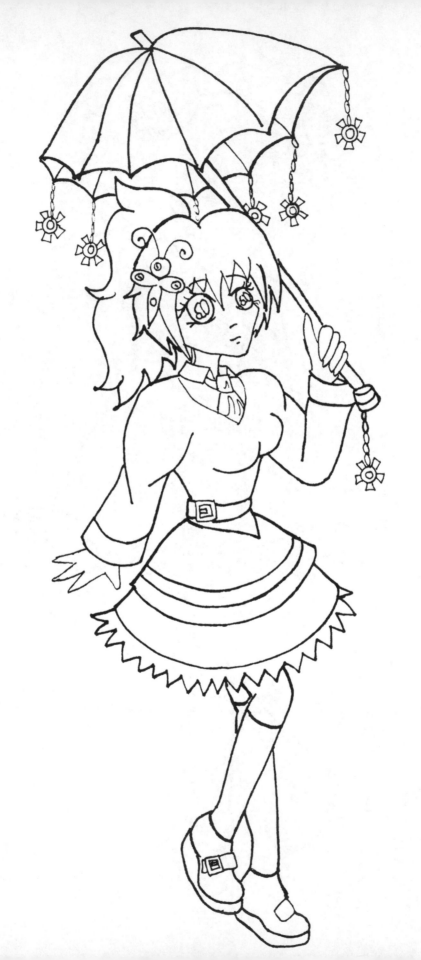

TWIST CANDY

Boil 3 pounds of common sugar and one pint of water over a slow fire without skimming. When boiled enough take it off, rub your hands in butter; take that which is a little cooled and pull it as you would molasses candy, until it is white; then twist or braid it and cut it into strips.

KISSES

2 cupsful powdered sugar, the whites of 3 eggs, 2 cupsful coconut, 2 teaspoonful baking powder; mix all together; drop upon buttered paper and bake until slightly brown in a brisk oven.

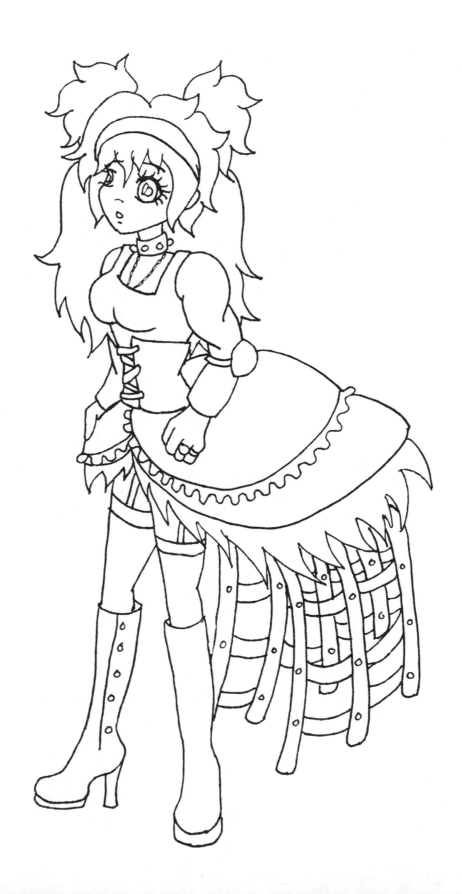

STEAMPUNK JEWELRY

Visit thrift shops to find broken watches
and take them apart carefully.
Use the watch faces and
inner workings to create
earrings and pendants.
Use your imagination
to add other small pieces like
old keys and compasses,
beautiful buttons,
velvet ribbon, lace bits,
and metal beads.
Craft stores
will have
the small
loops
needed
to hold
the pieces
together.

Have fun! Be creative!

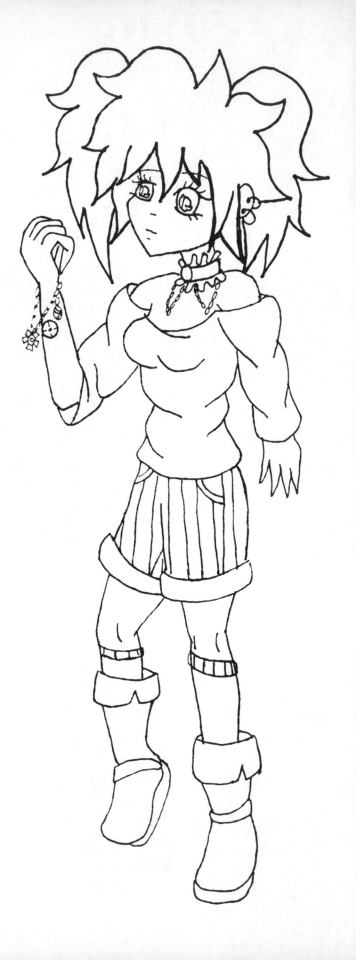

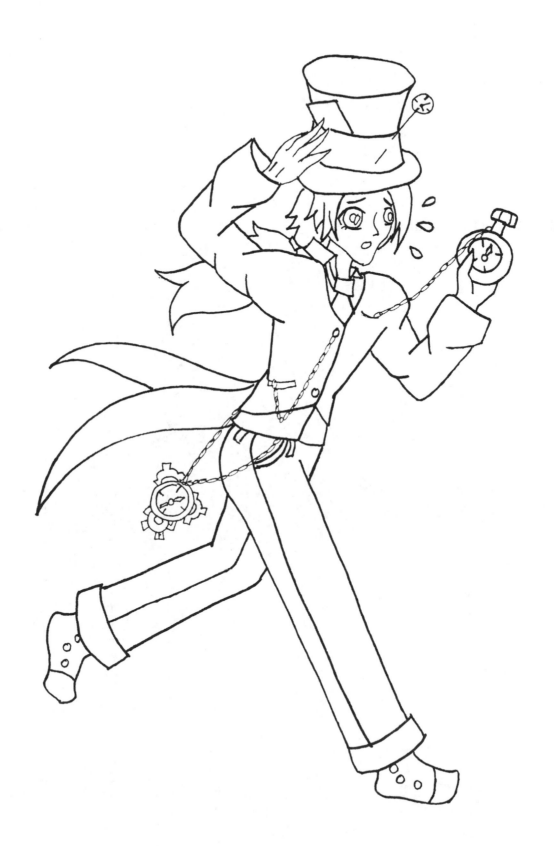

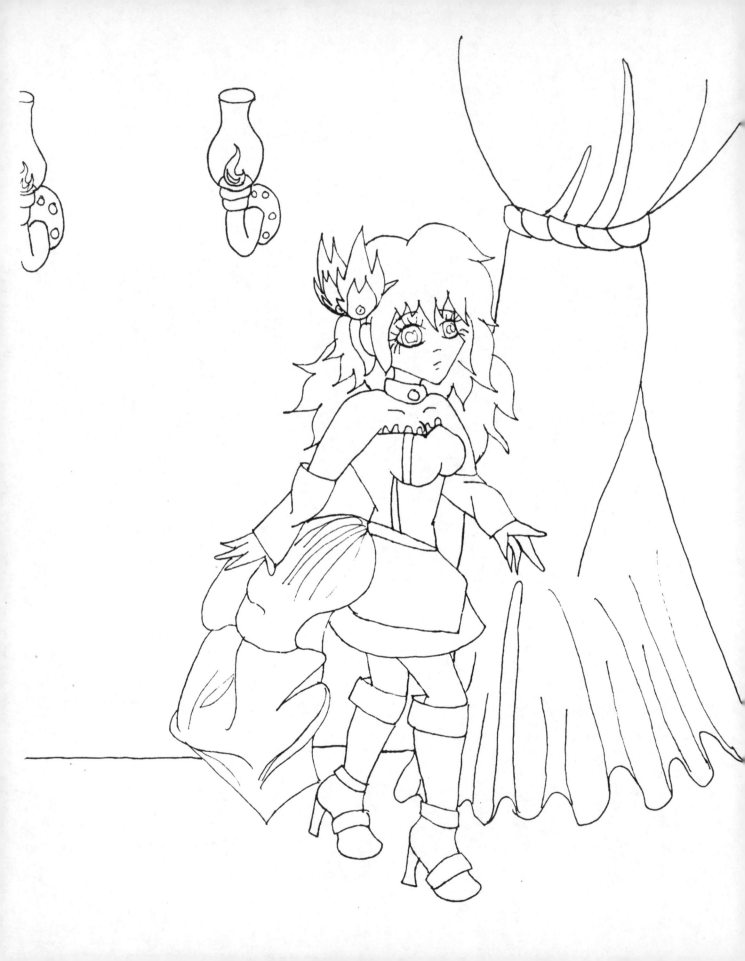

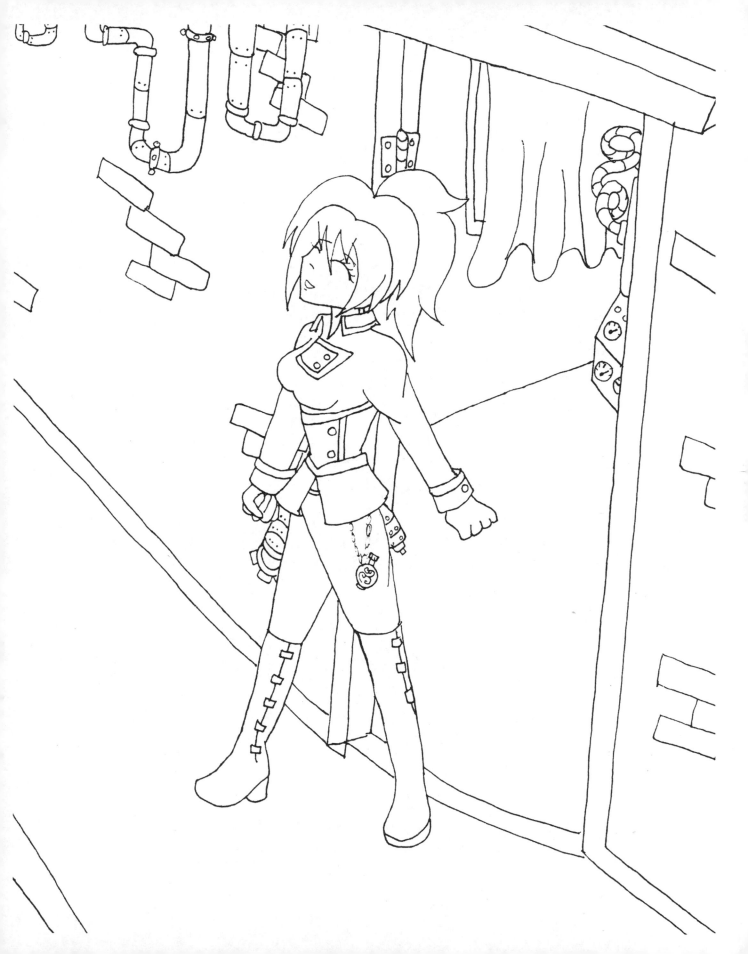

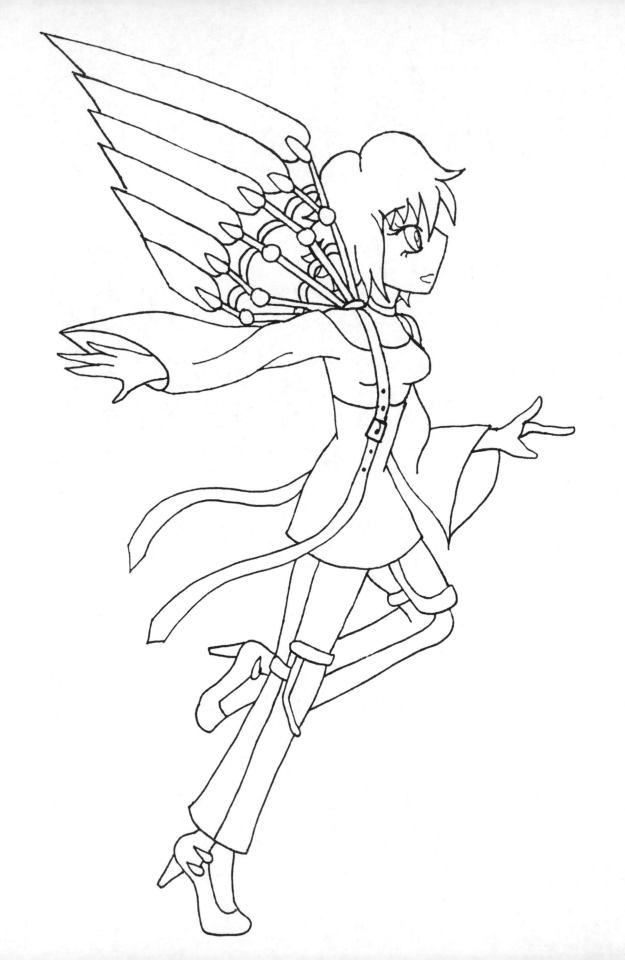

SECRET MESSAGES
with Invisible Ink

1. Squeeze the undiluted juice of one lemon into a small vessel.

2. Use a thin paintbrush to write a message on a blank piece of thick paper.

3. Let the paper dry completely.

4. Write a message in regular ink on the paper to disguise the secret message.

5. To make the secret message visible, heat the paper carefully using an iron or other low heat source until the hidden words appear.

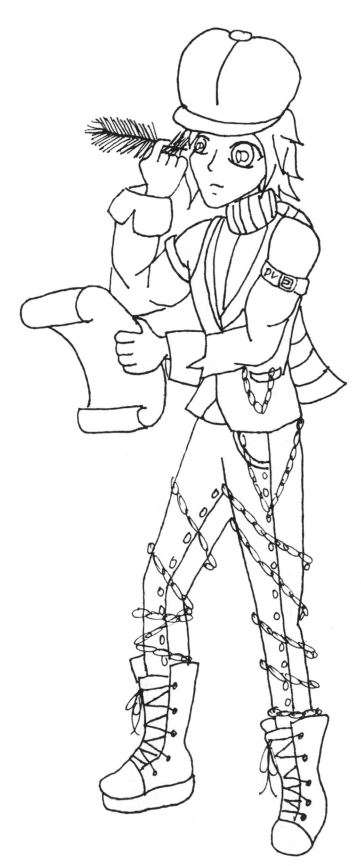

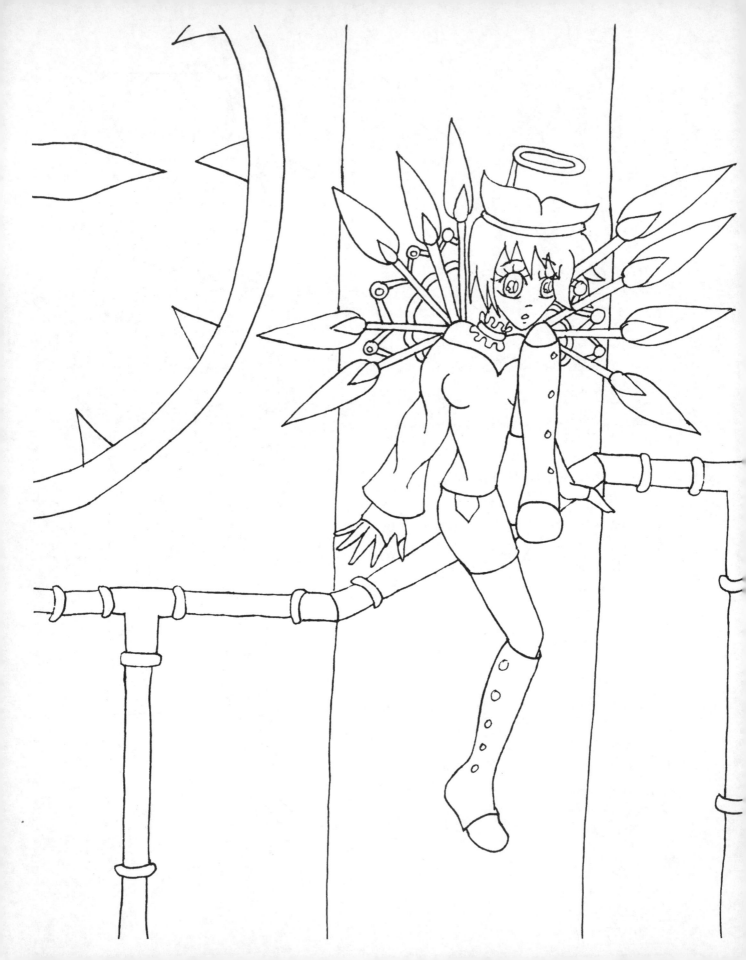

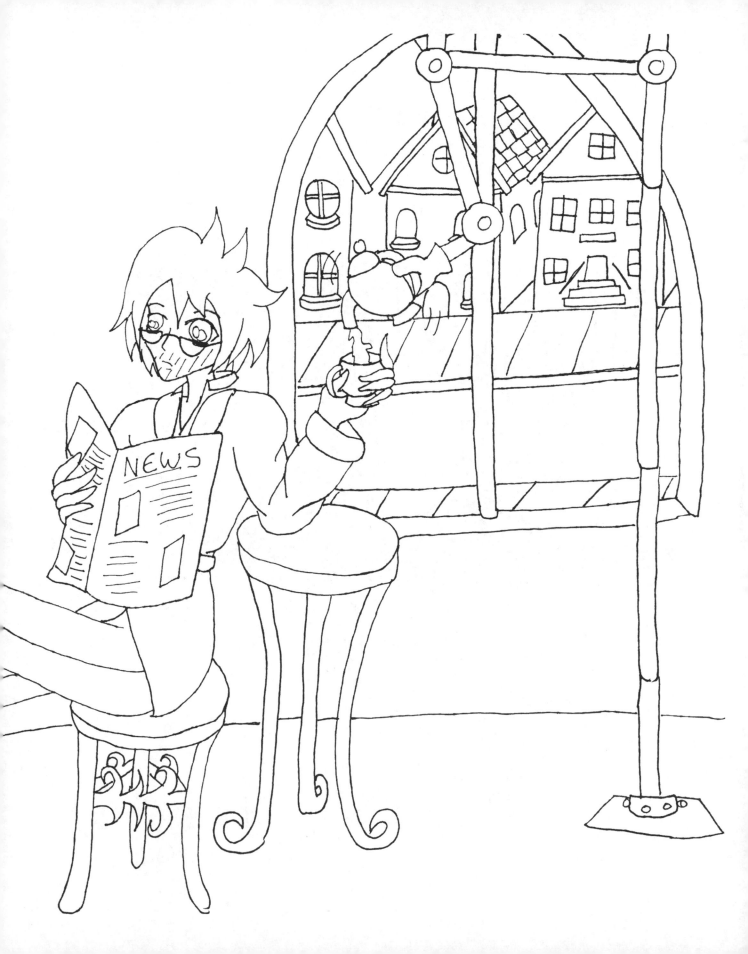

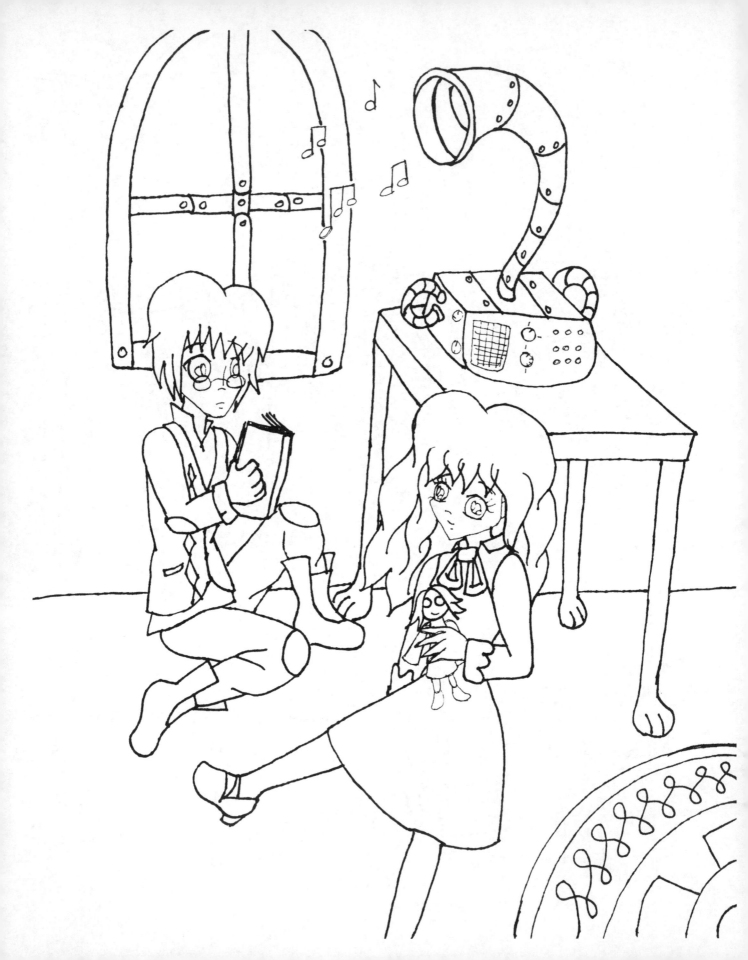

Last night this boy's father looked at
a picture hanging on the wall and said,
"Brothers and sisters have I none,
but that man's father is my father's son."

Who is in the picture?

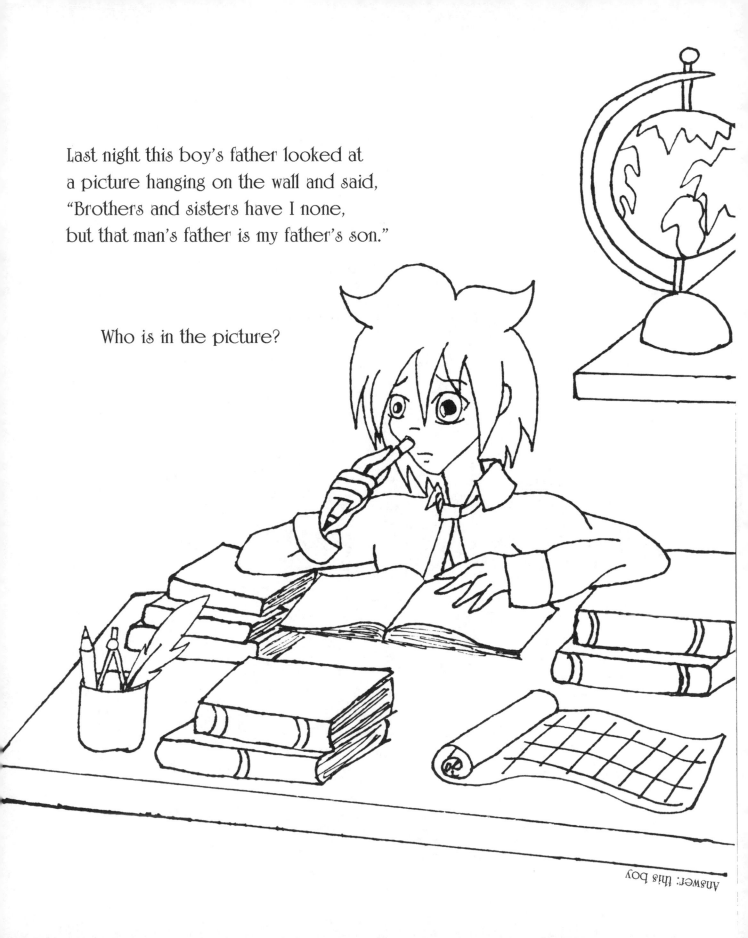

Answer: this boy

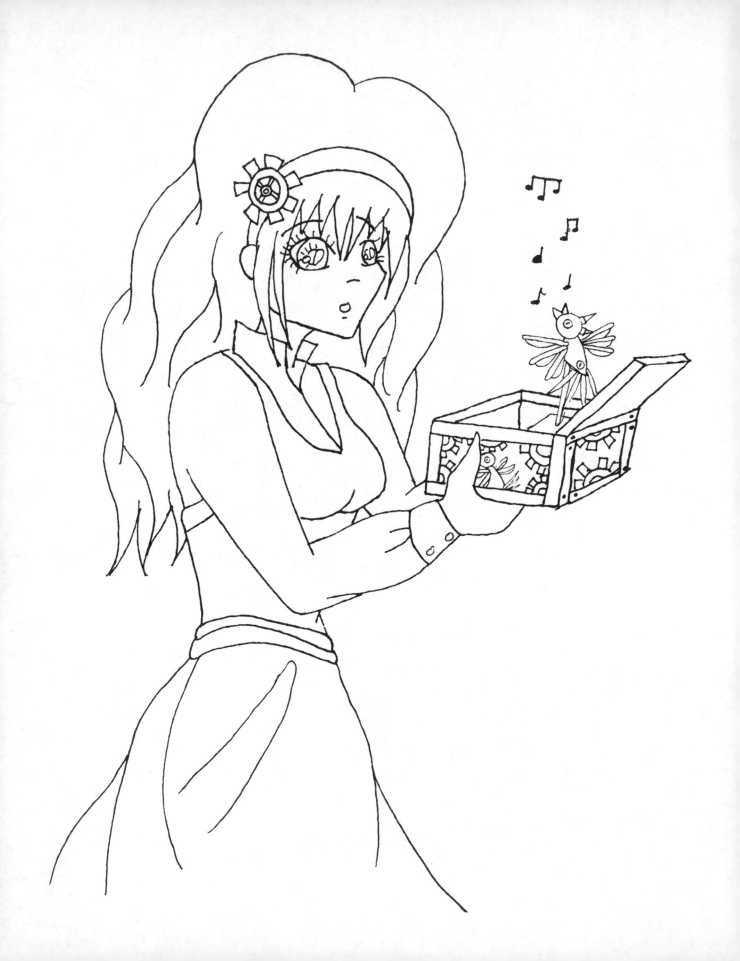

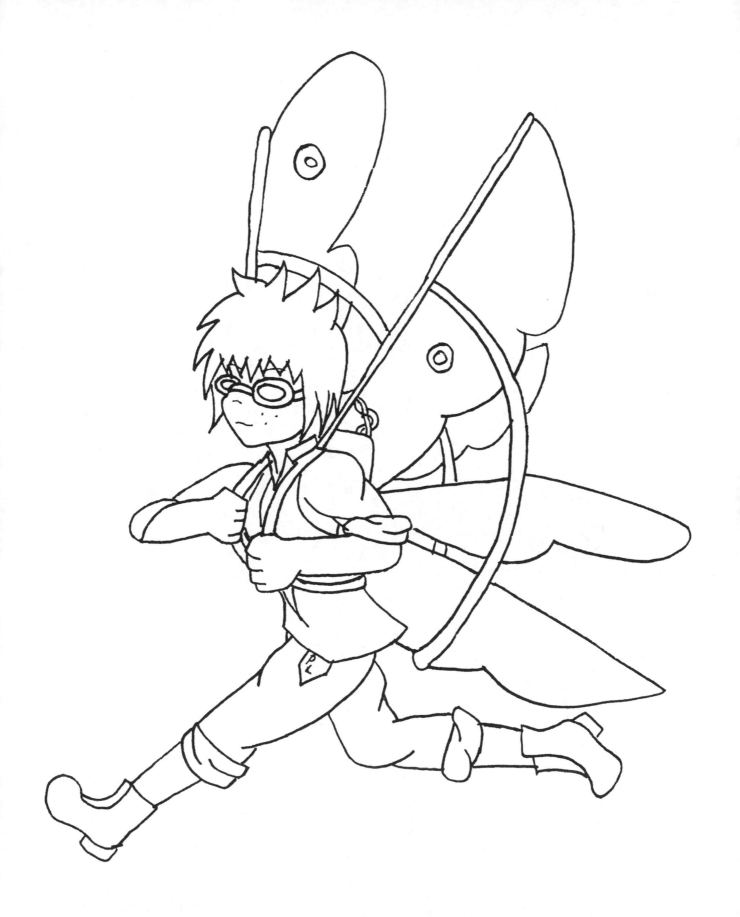

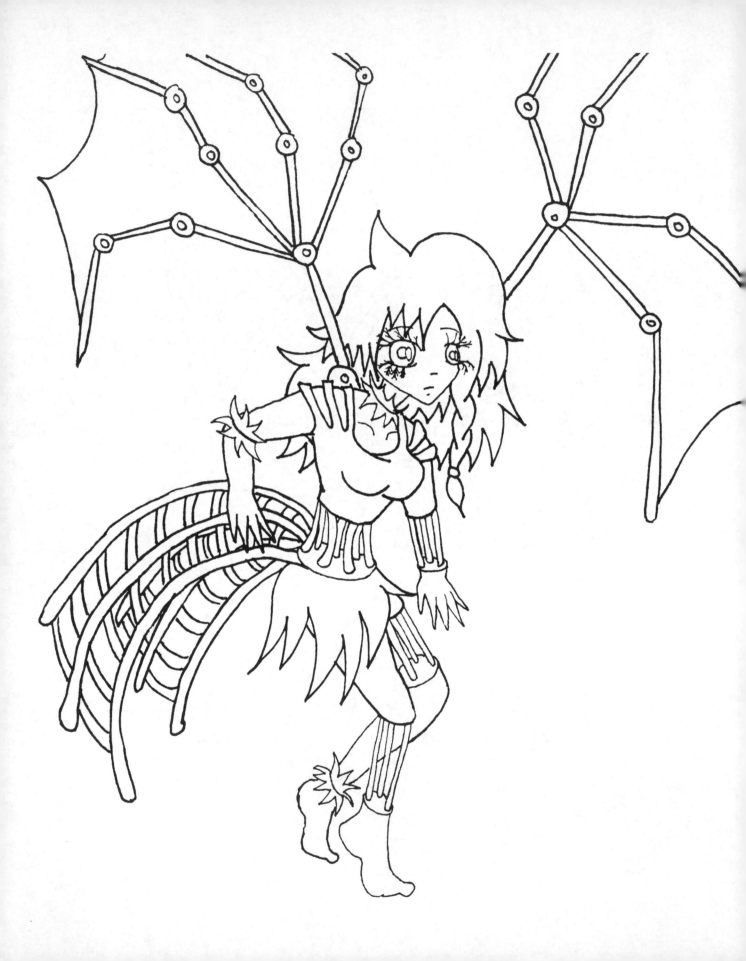

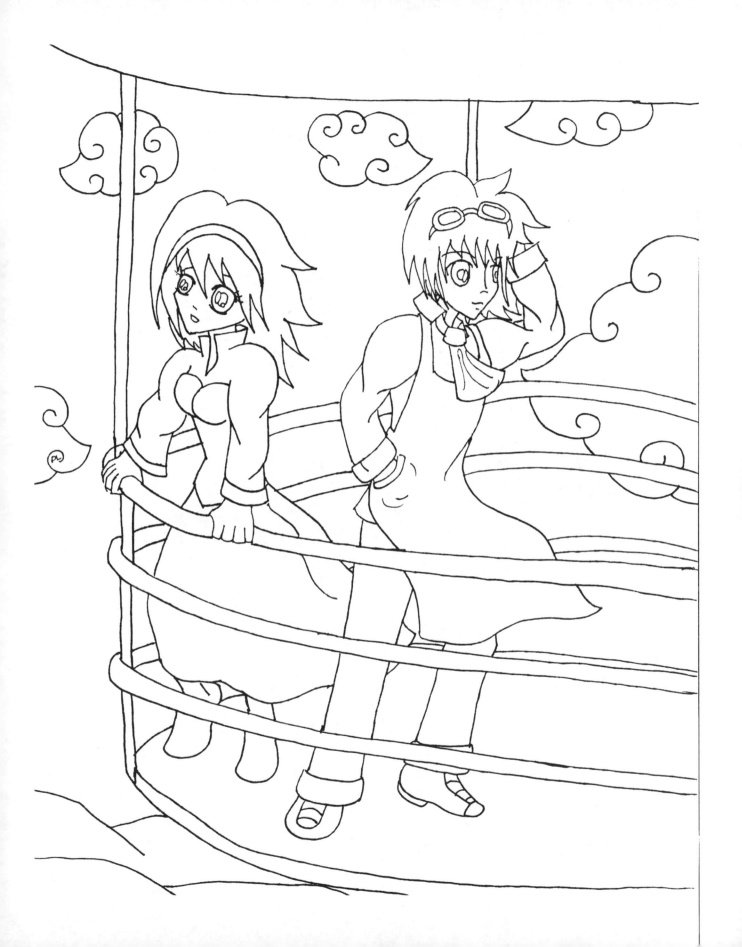

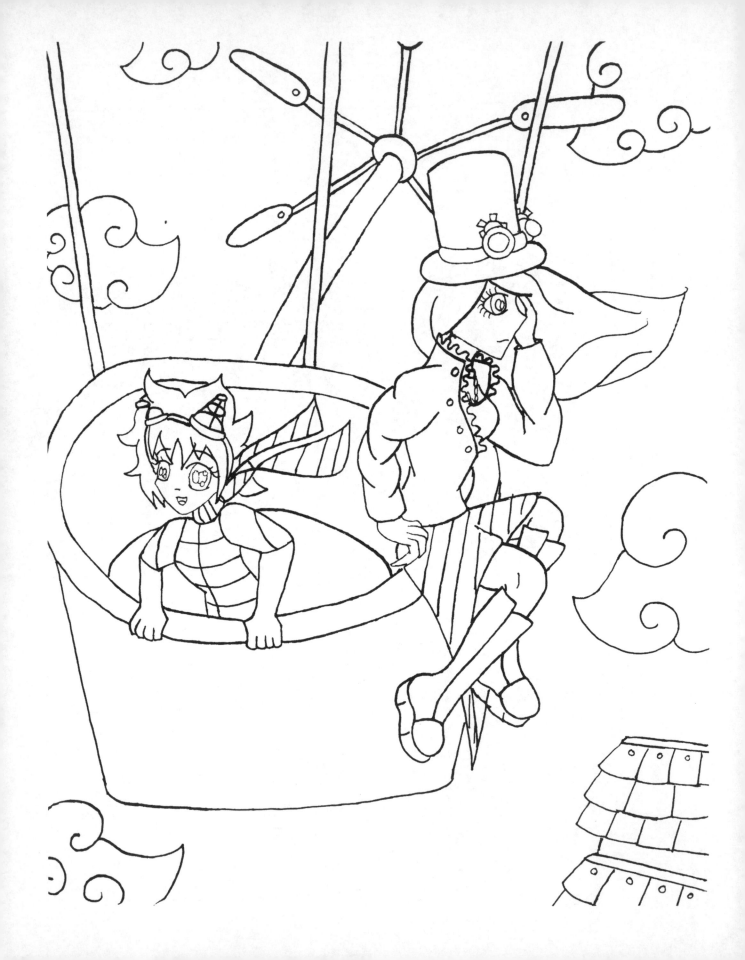

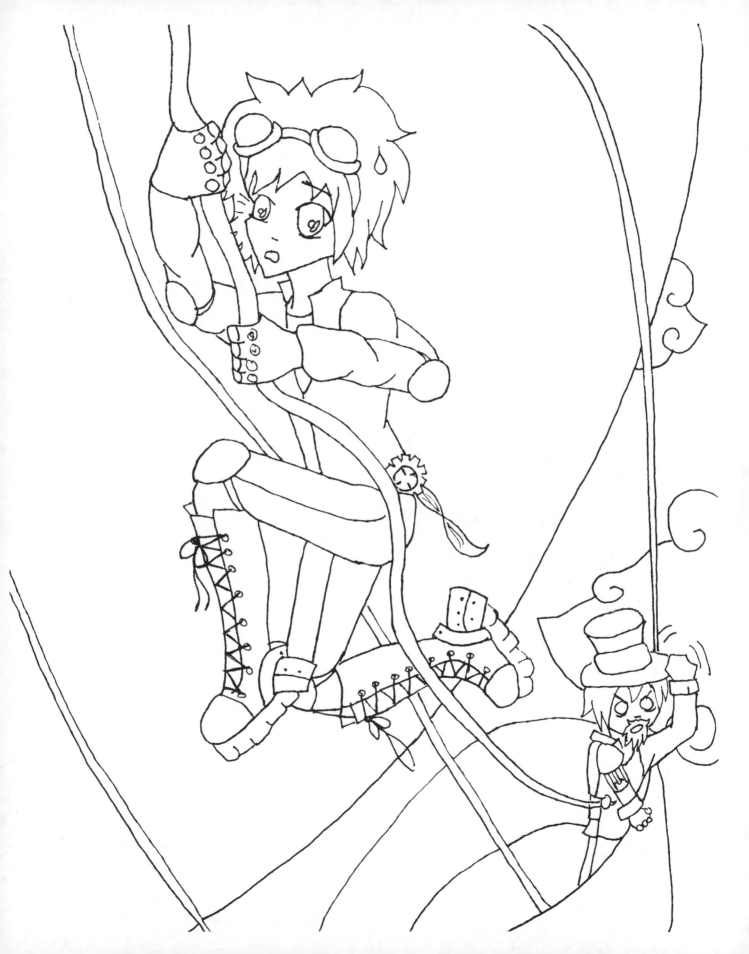

Draw the Professor's Steampunk Machine ...

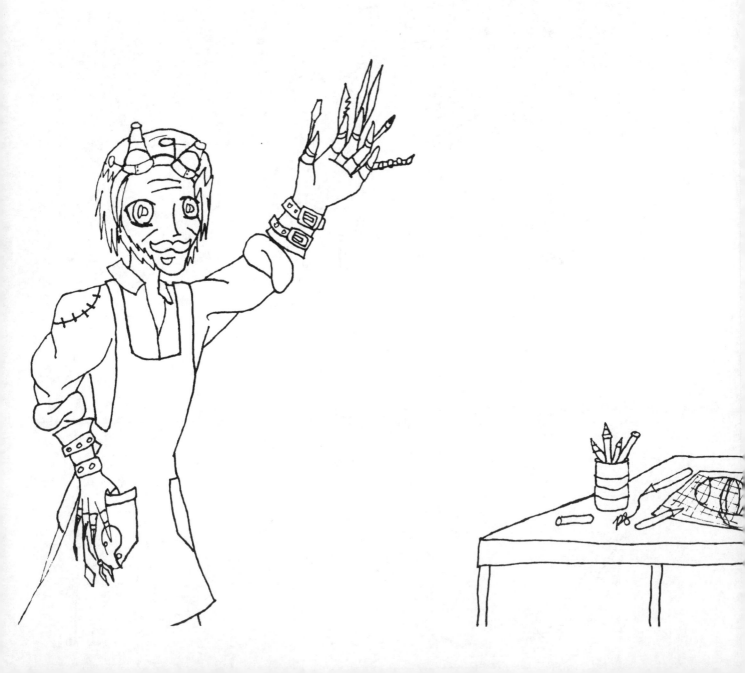

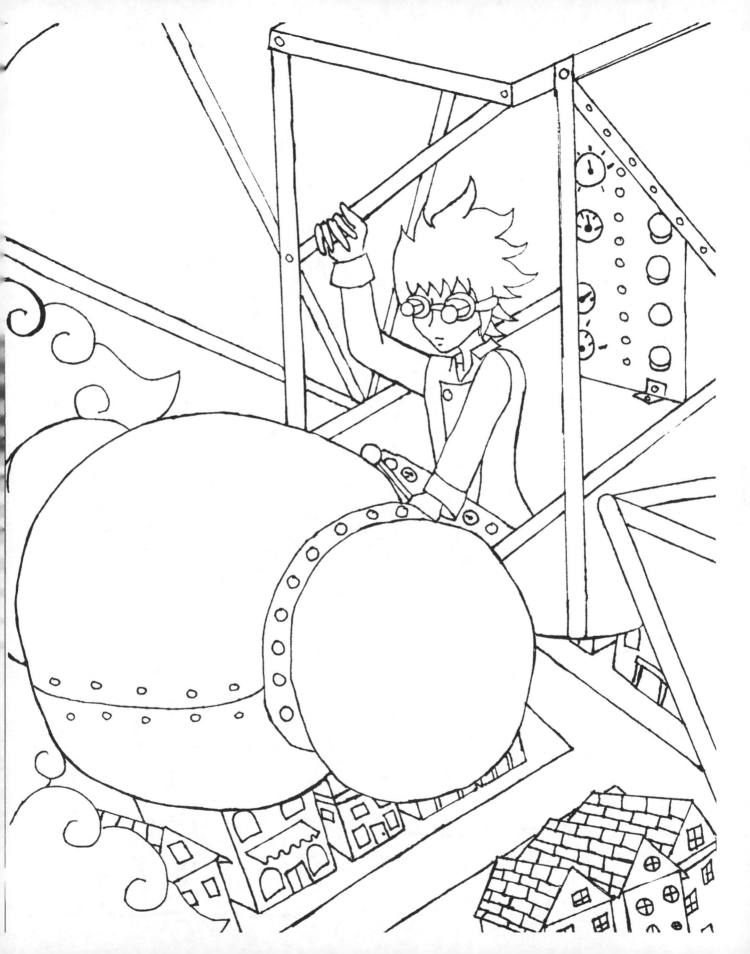

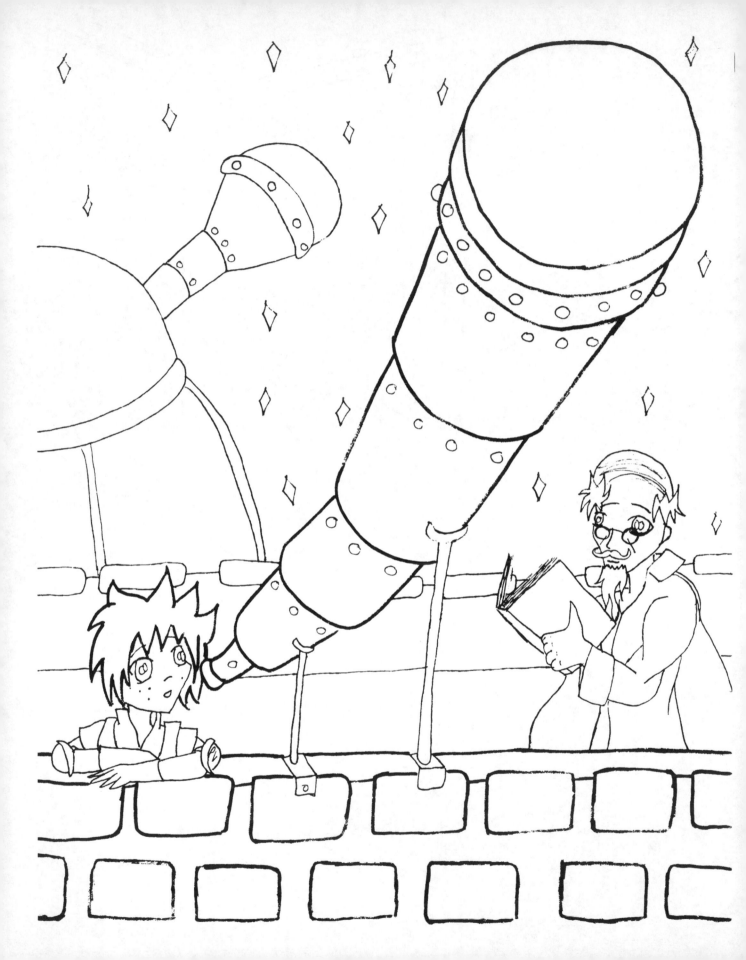

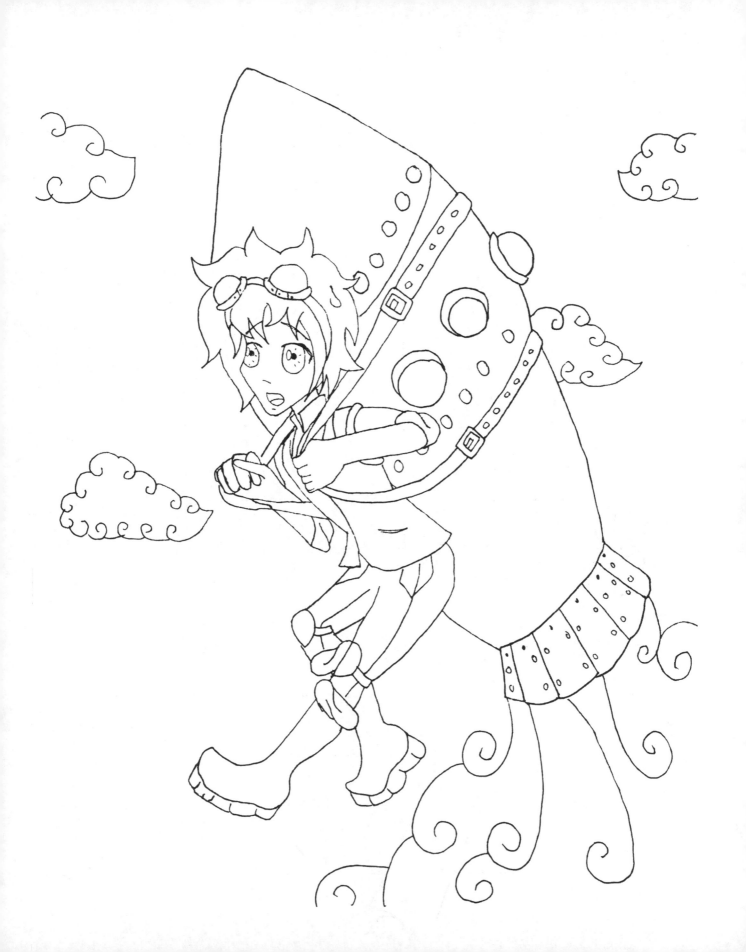

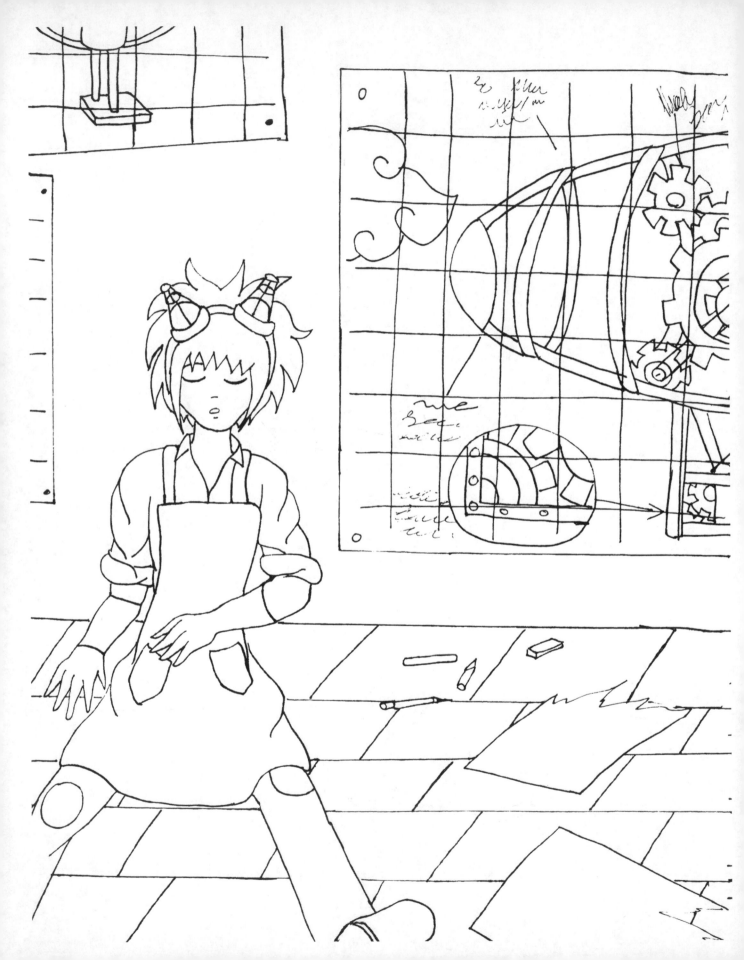

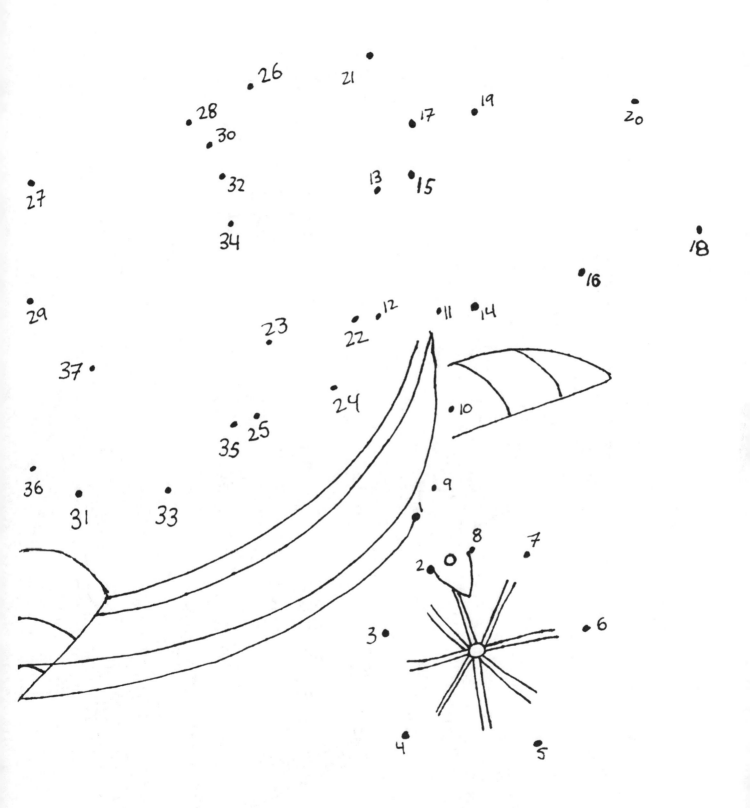

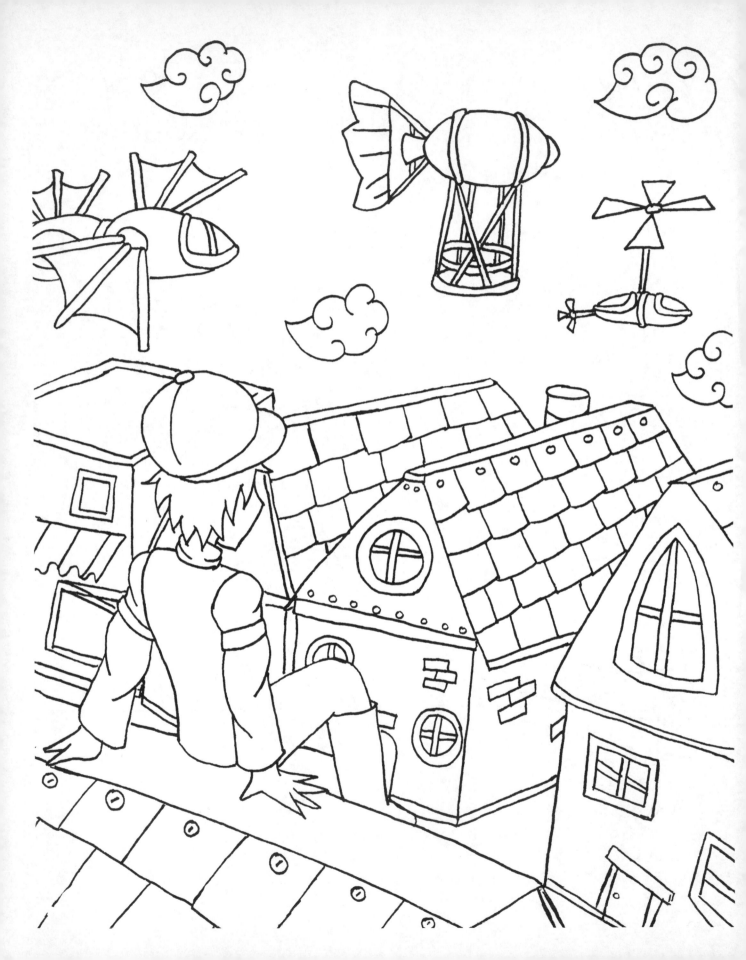

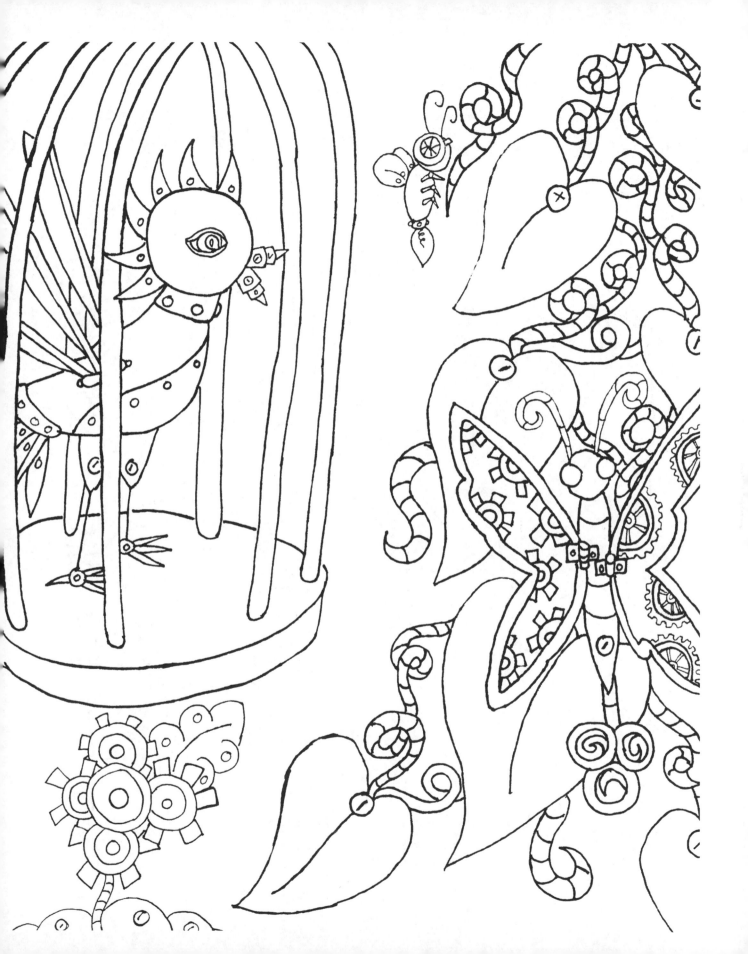

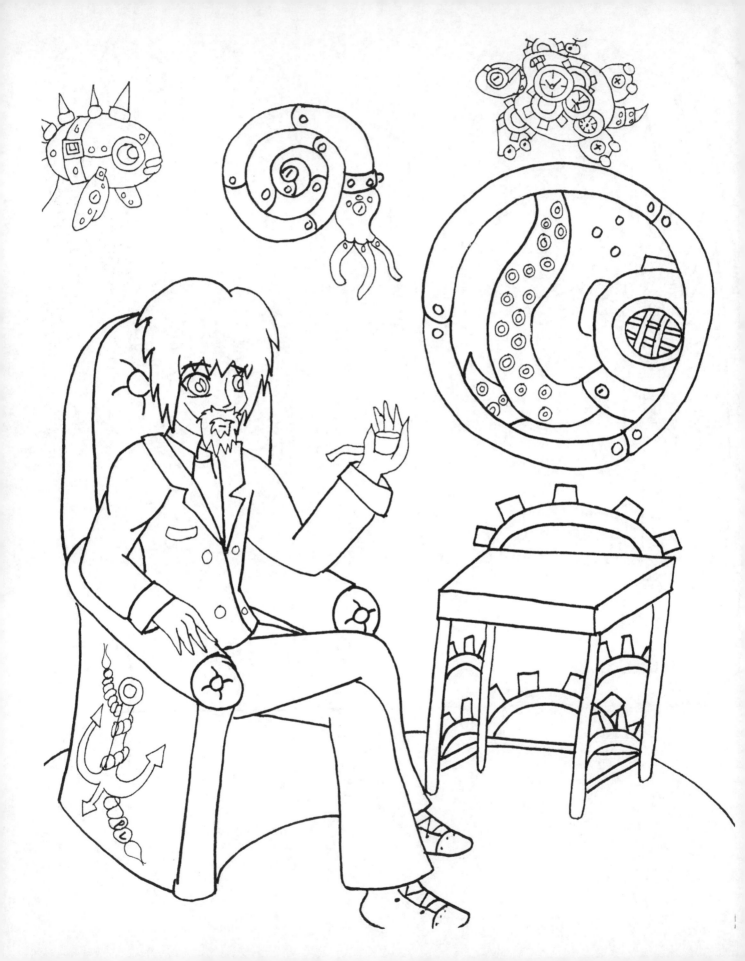

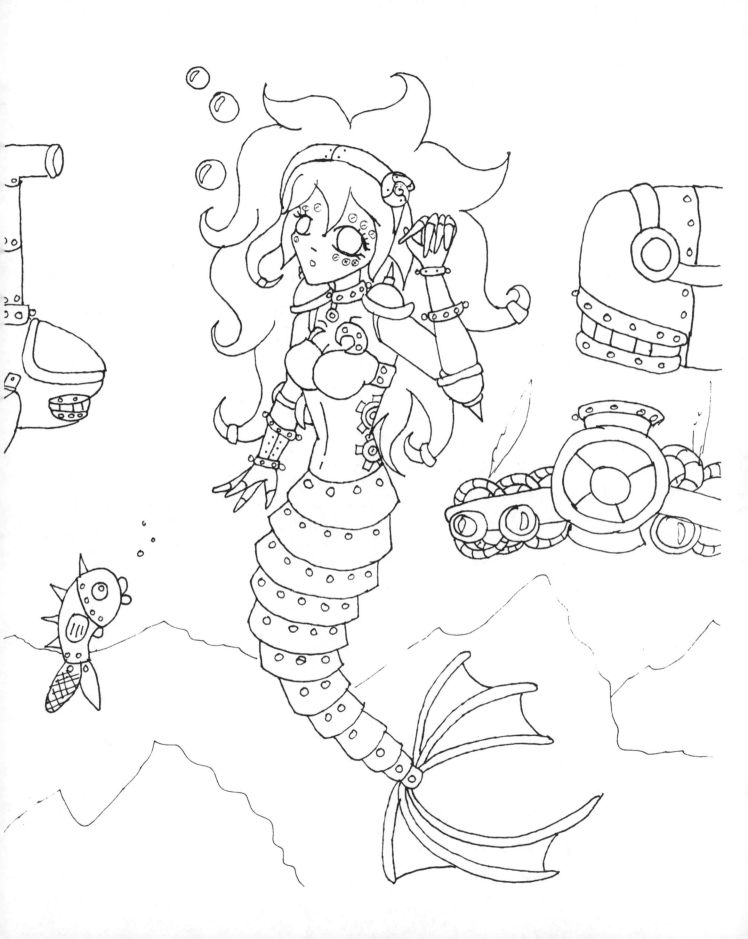

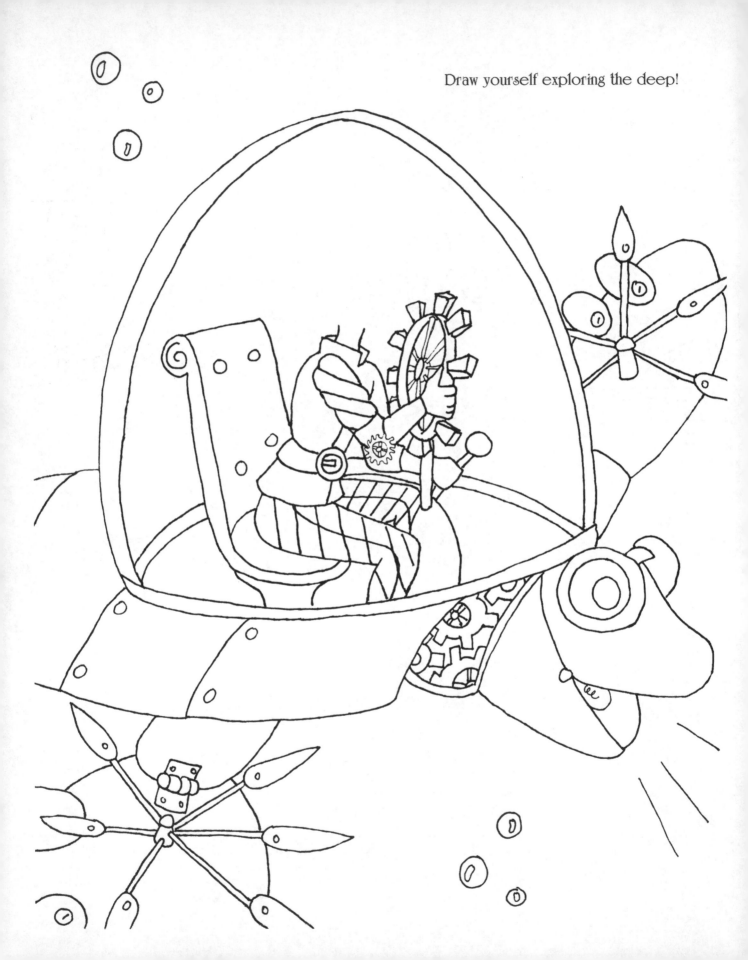

Draw yourself exploring the deep!

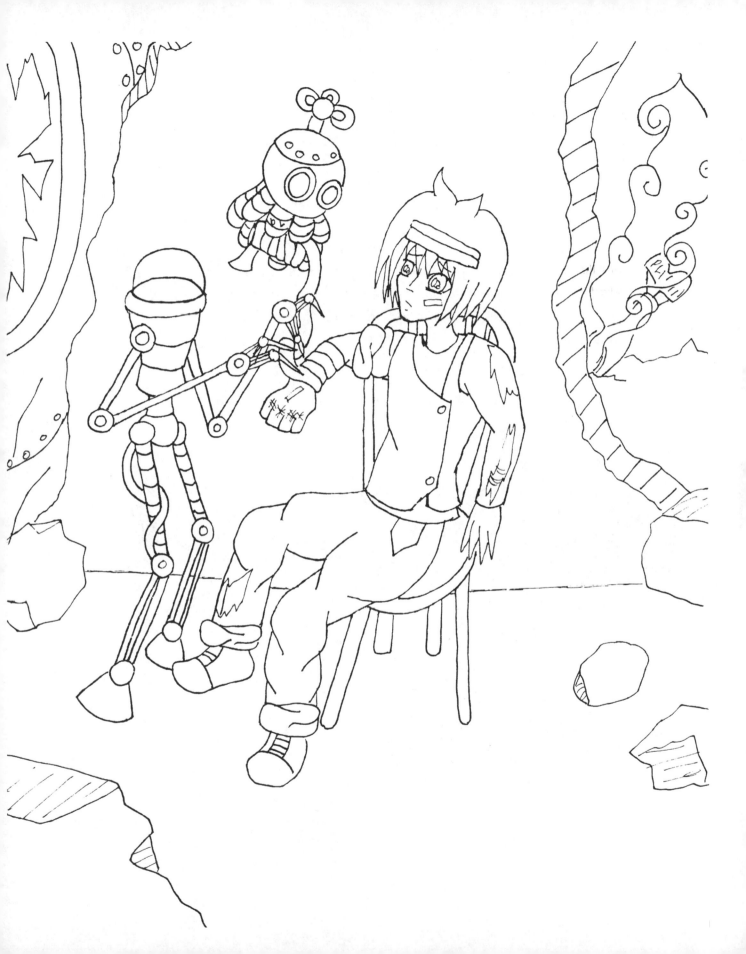

GINGER SNAPS

One cup brown sugar, two cups molasses, one large cup butter,
two teaspoonfuls soda, two teaspoonfuls ginger, three pints flour to
commence with; rub shortening and sugar together into the flour; add
enough more flour to roll very smooth, very thin, and bake in a quick
oven. The dough can be kept for days by putting it in the flour barrel
under the flour, and bake a few at a time The more flour that can be
worked in and the smoother they can be rolled, the better and more
brittle they will be. Should be rolled out to wafer-like thinness.
Bake quickly without burning.

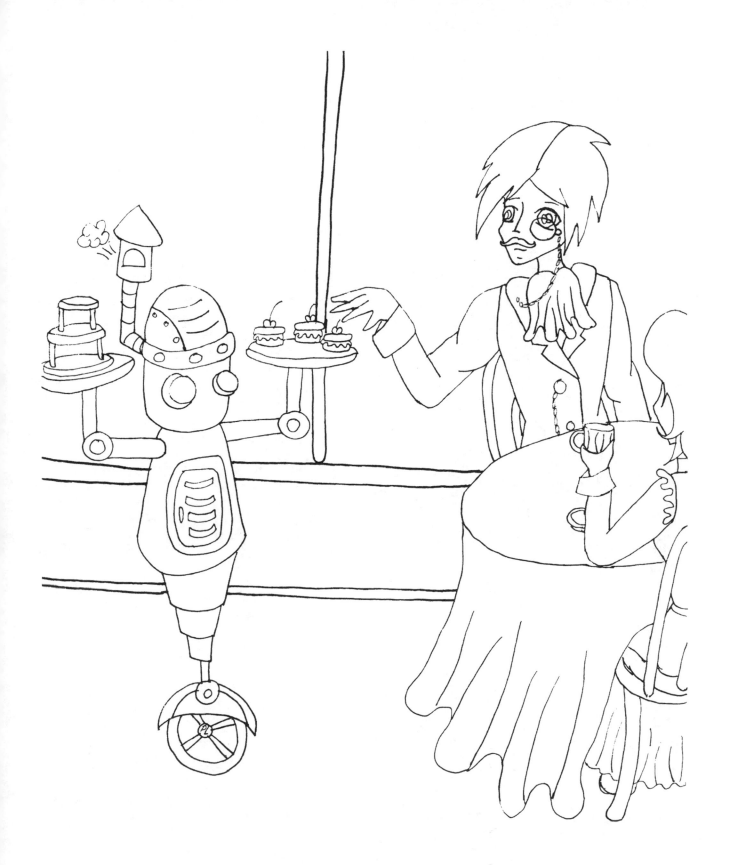

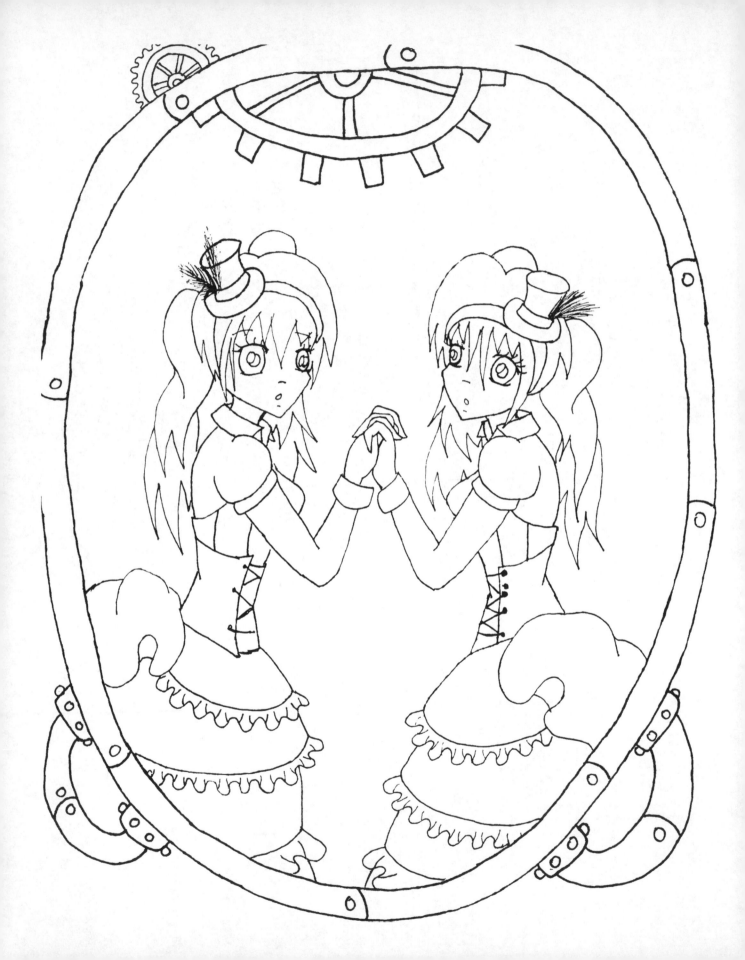

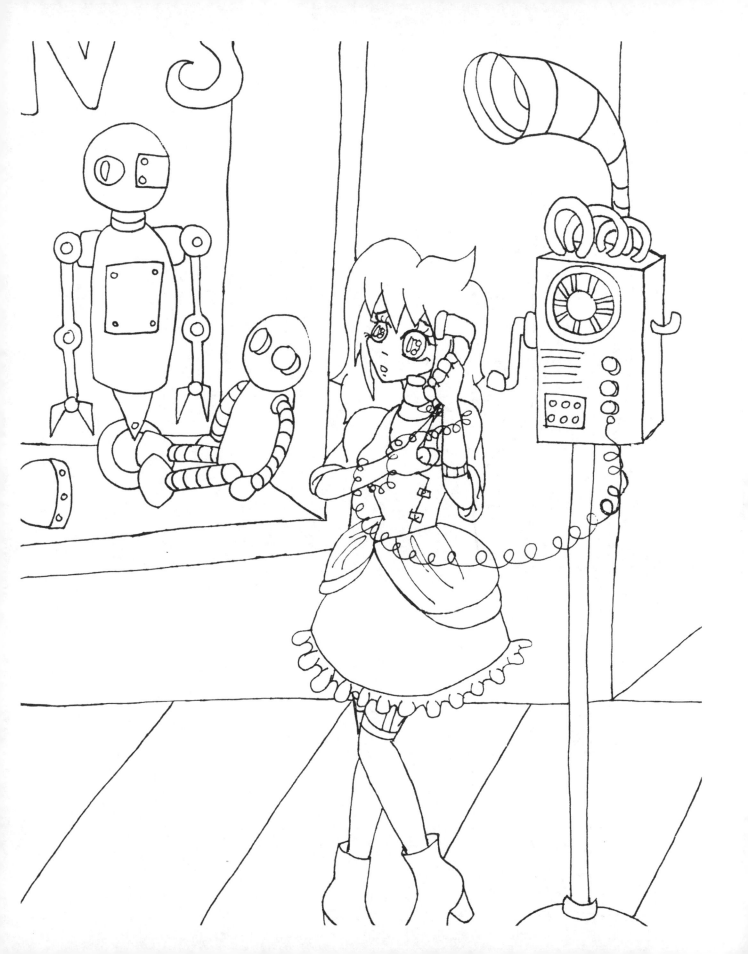

Create your own Steampunk costume!

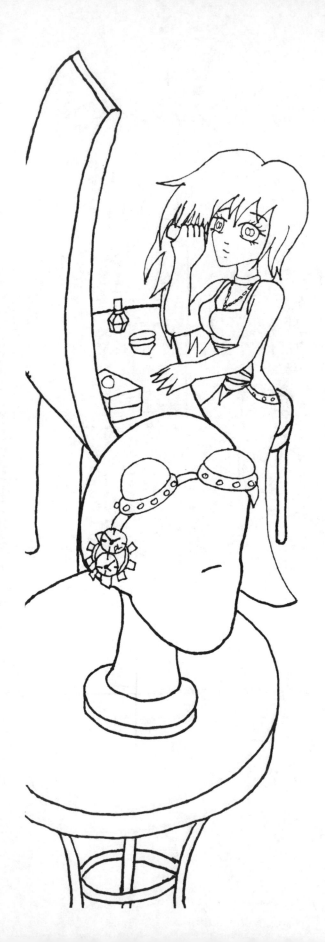

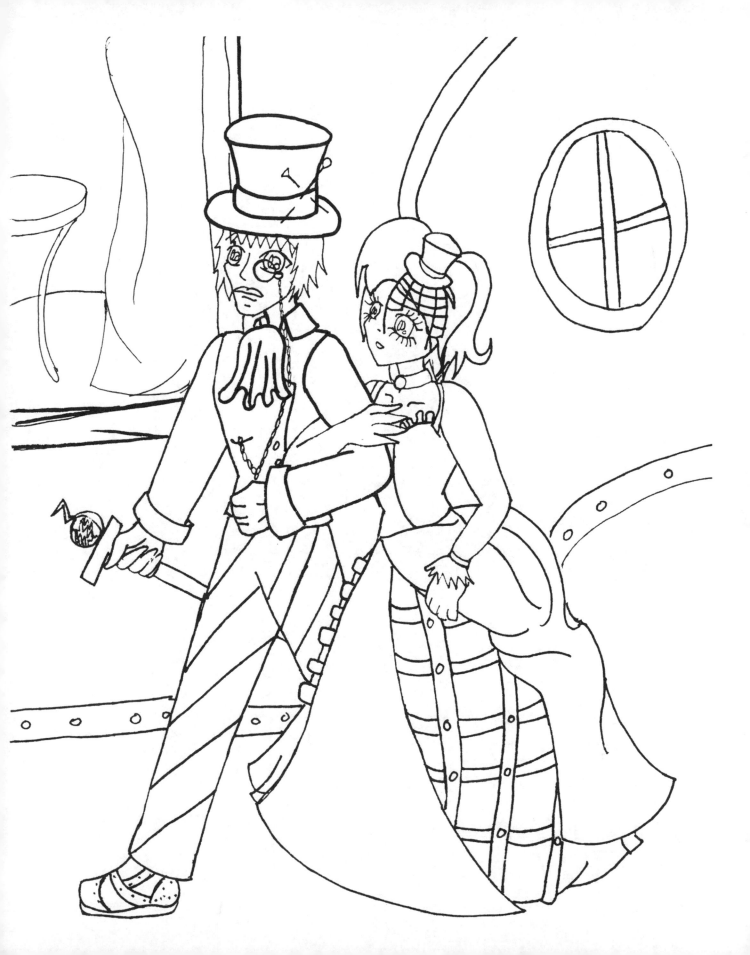

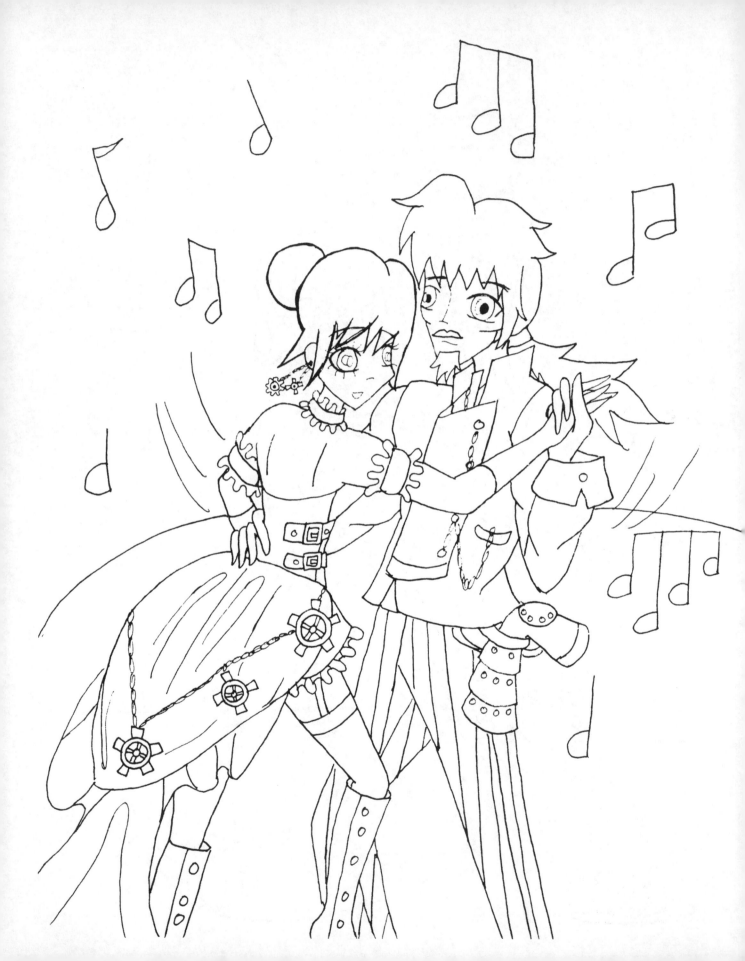

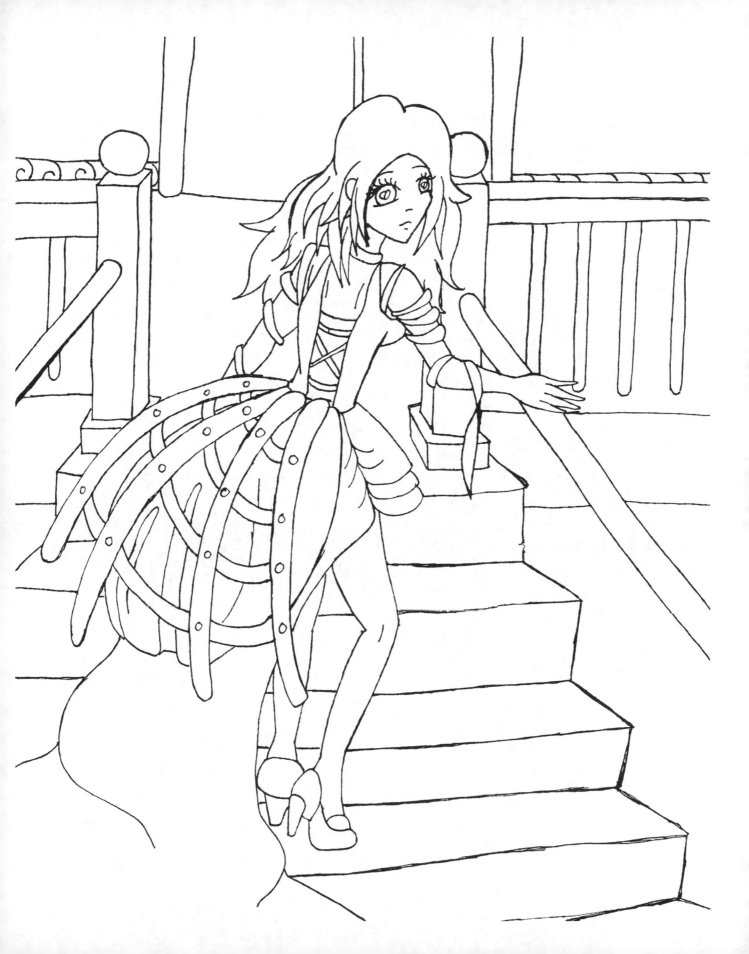

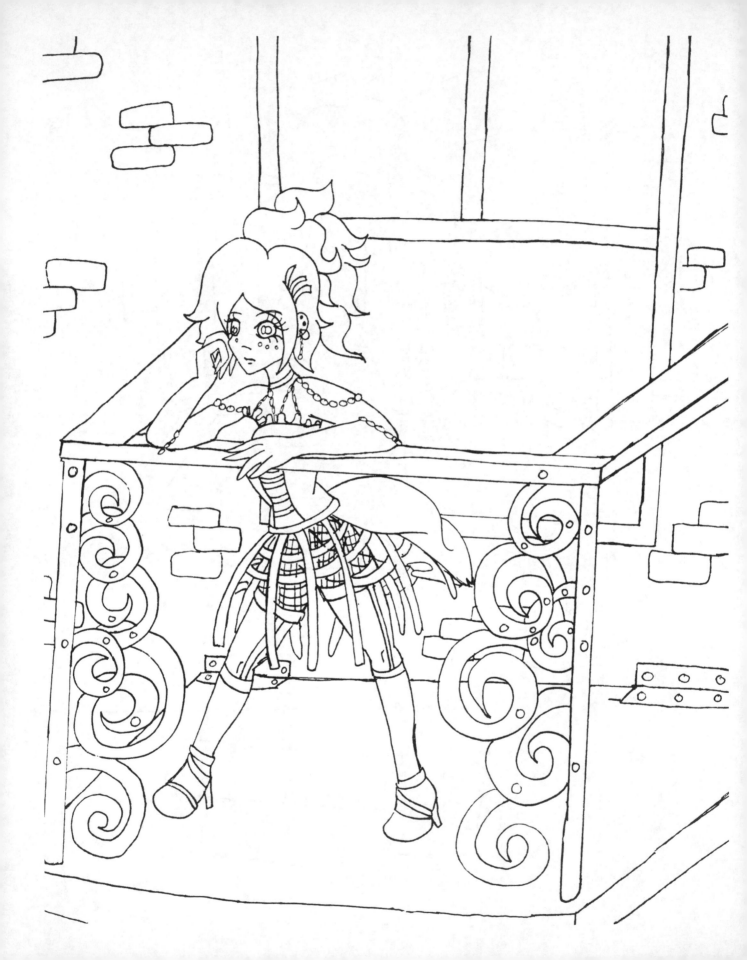

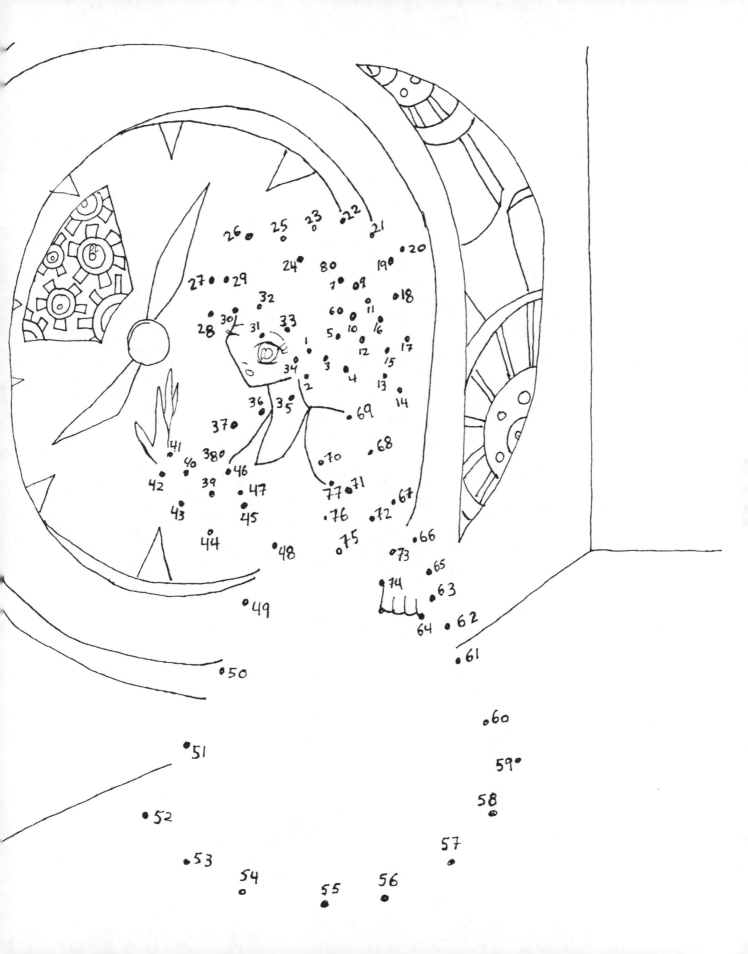

How many words can you make out of STEAMPUNK?

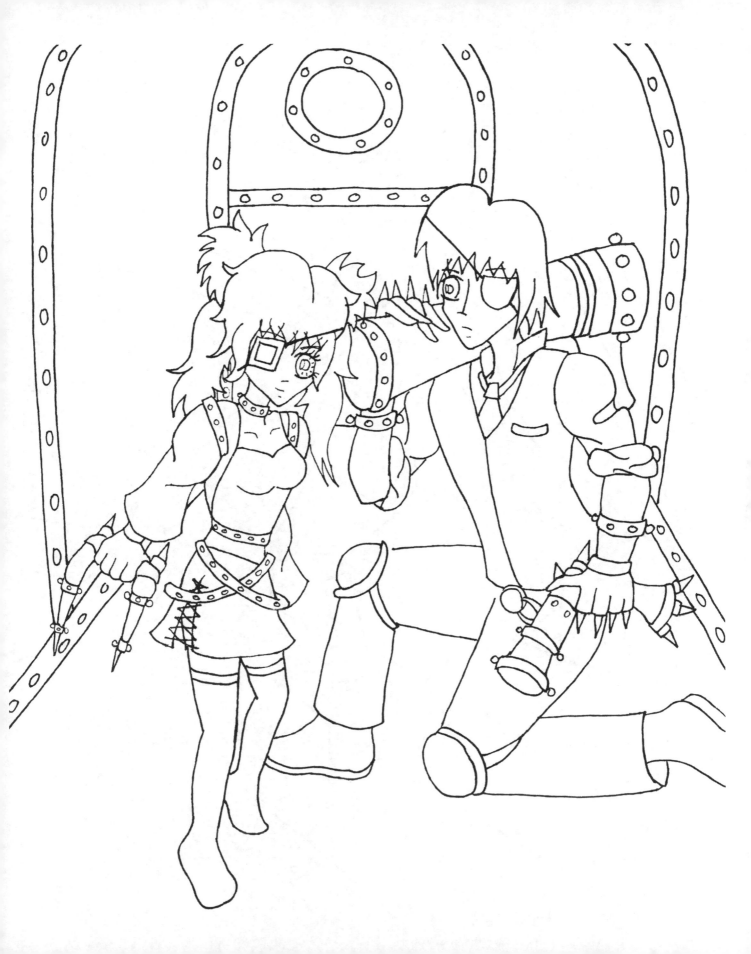

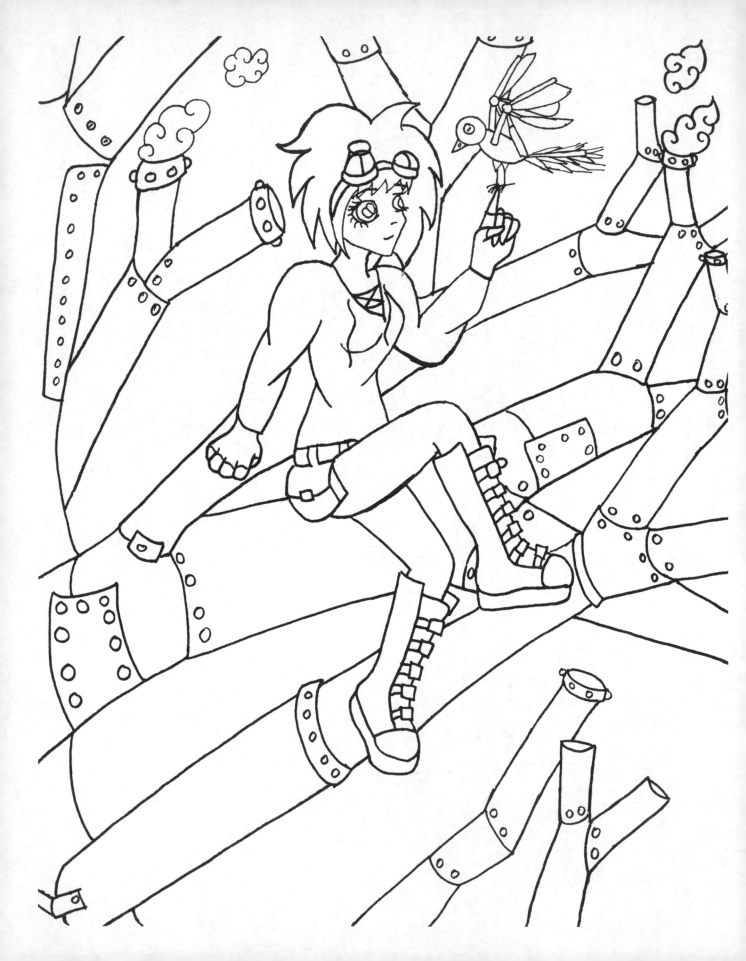

Find these words: Monocle Steam Gears Create

Goggle Airship Clockwork Fly Dream Punk Art

S	J	E	T	A	E	R	C
A	T	L	Z	U	Y	D	L
I	G	E	A	R	S	H	O
R	O	C	A	J	O	N	C
S	G	E	R	M	U	H	K
H	G	R	T	G	P	N	W
I	L	F	L	Y	U	U	O
P	E	R	T	P	U	I	R
M	O	N	O	C	L	E	K
M	A	E	R	D	N	J	X
E	B	E	O	H	P	Y	B

The apothecary sells his potions by weight and usually has them organized heaviest to lightest. But after a day in the market, they all got mixed up! He knows that the heart-shaped bottle is half the weight of the rectangular one to the right. He also knows that the bottle to the far left is three times one-fourth the weight of the rectangular one and the circular bottle is the sum of all the other three, 45 oz.

How much does each bottle weigh?

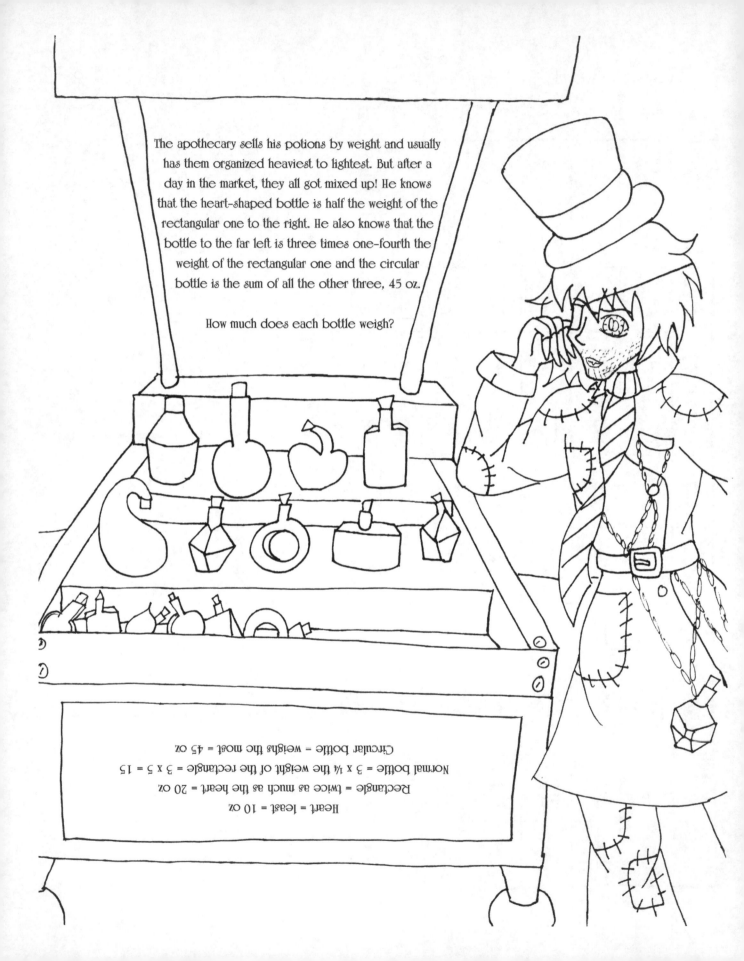

Heart = least = 10 oz

Rectangle = twice as much as the heart = 20 oz

Normal bottle = 3 x 1/4 the weight of the rectangle = 3 x 5 = 15

Circular bottle = weighs the most = 45 oz

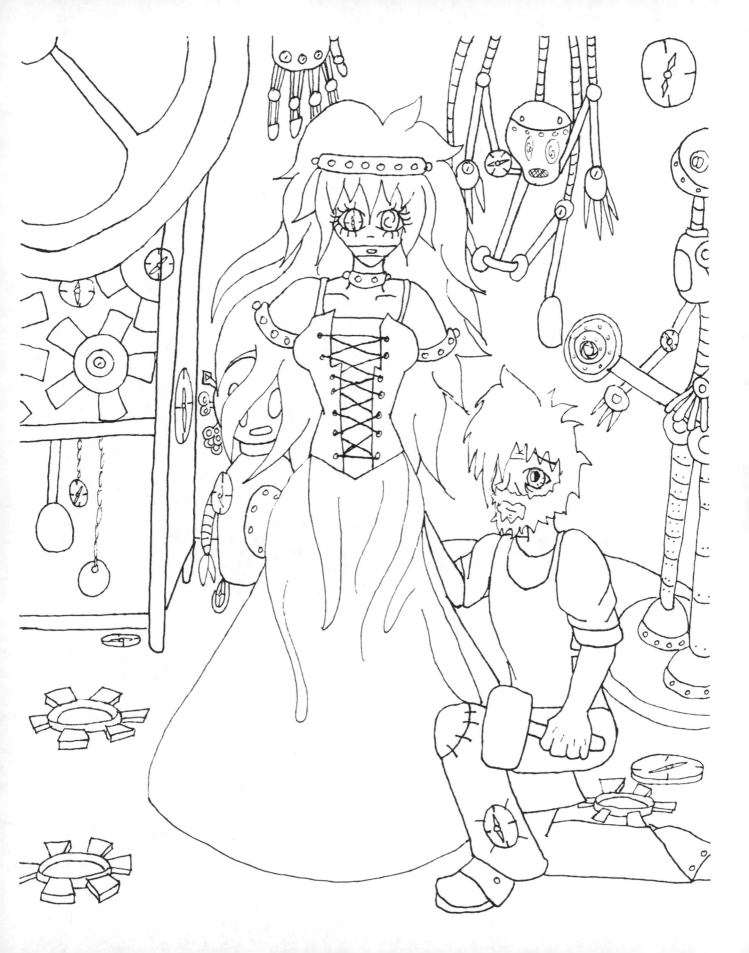

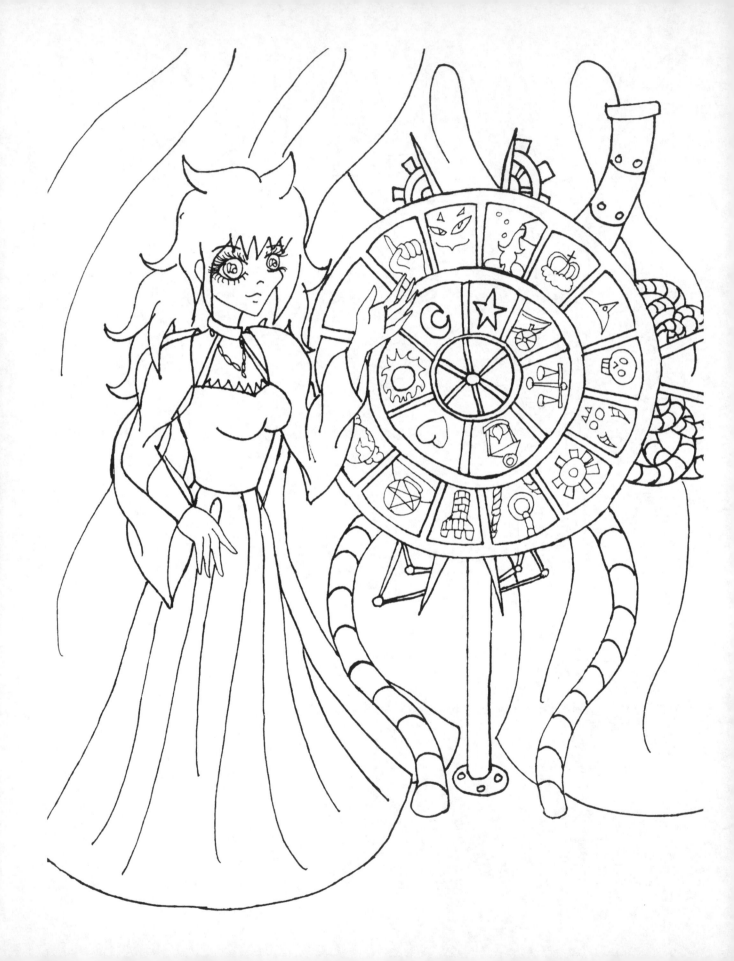

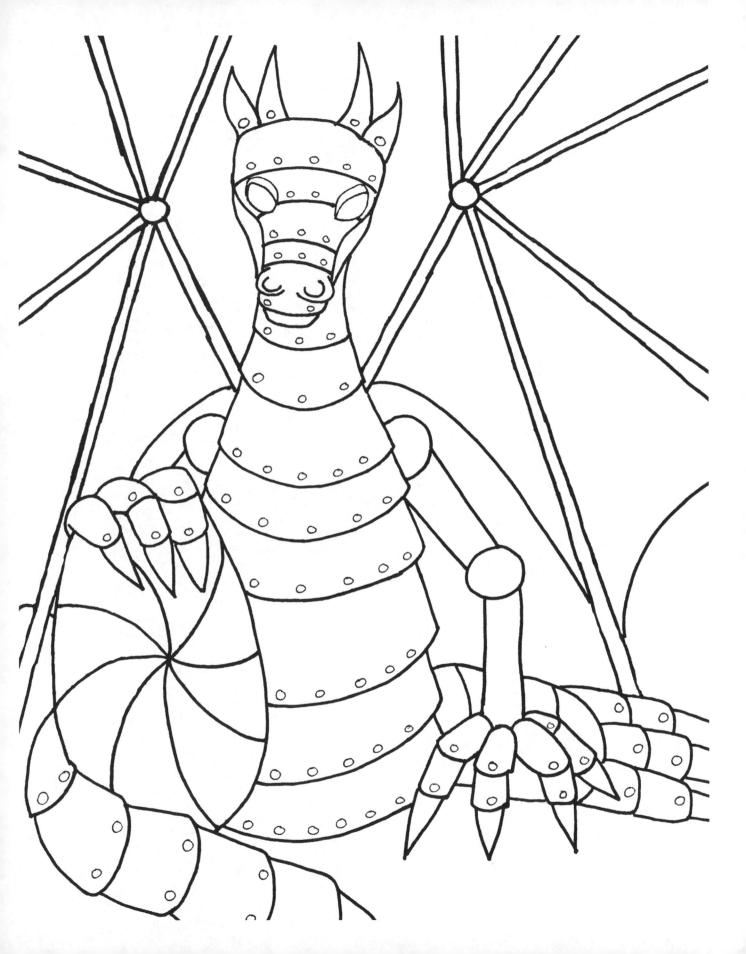

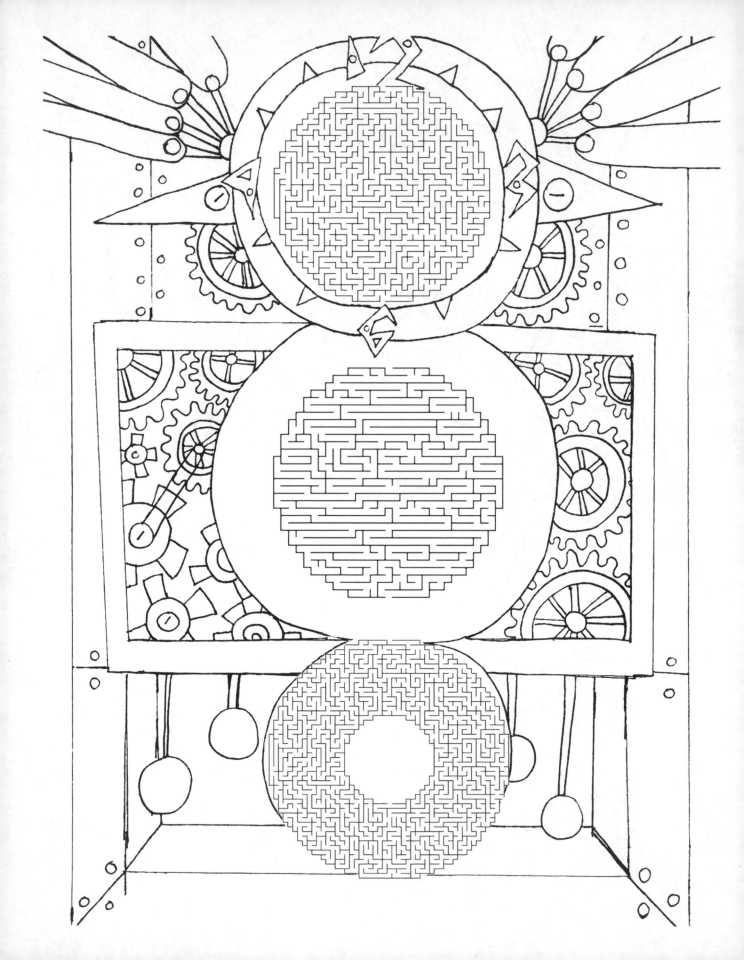

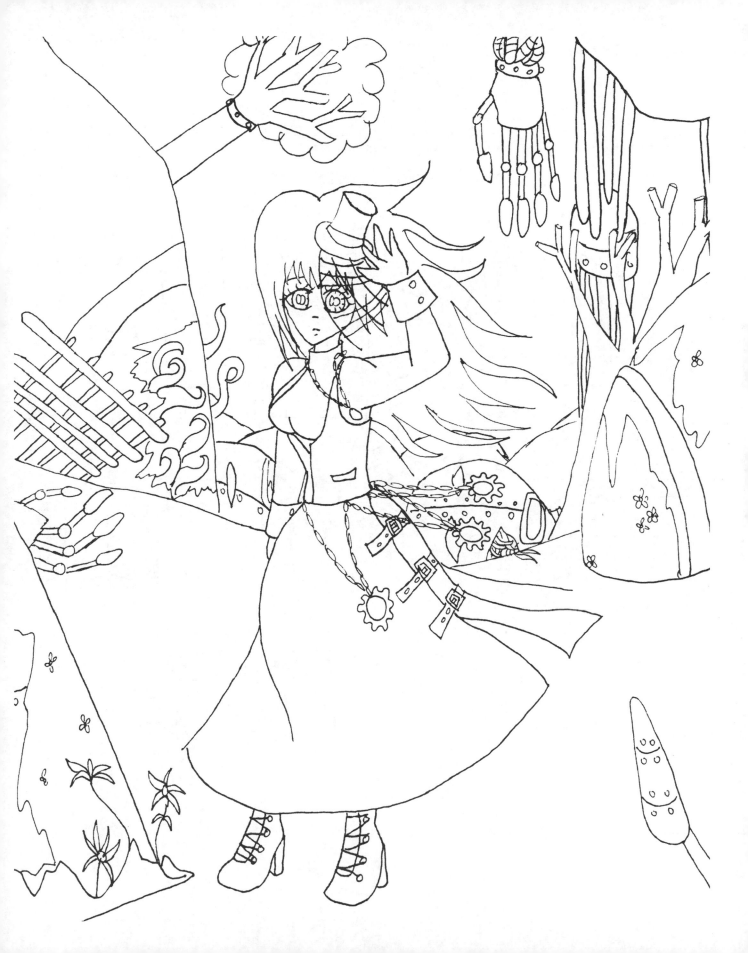